HANDBOOK TO PASTEL

BY

MAD^{ELLE} MARIE GUERIN

ELÈVE DE M. JULES L. MACHARD

TRANSLATED BY G. A. BOUVIER

Copyright © 2013 Read Books Ltd.
This book is copyright and may not be
reproduced or copied in any way without
the express permission of the publisher in writing

British Library Cataloguing-in-Publication Data
A catalogue record for this book is available from the
British Library

Drawing and Illustration

Drawing is a form of visual art that can make use of any number of drawing instruments, including graphite pencils, pen and ink, inked brushes, wax colour pencils, crayons, charcoal, chalk, pastels and various kinds of erasers, markers, styluses, metals (such as silverpoint) and even electronic drawing. As a medium, it has been one of the most popular and fundamental means of public expression throughout human history – as one of the simplest and most efficient means of communicating visual ideas.

Drawing itself long predates other forms of human communication, with evidence for its existence preceding that of the written word – demonstrated in cave paintings of around 40,000 years ago. These drawings, known as pictograms, depicted objects and abstract concepts including animals, human hands and generalised patterns. Over time, these sketches and paintings were stylised and simplified, leading to the development of the written language as we know it today. This form of drawing can truly be considered art in its purest sense – the basic forms on which all others build.

Whilst the term 'to draw' derives from the Old English *dragan* (meaning 'to drag, draw or protract'), the word 'illustrate' derives from the Latin word *illustratio*, meaning 'enlighten' or 'irradiate'. This process of 'enlightenment' is central to drawing and illustration as we know it today. Medieval codices' illustrations were often called 'illuminations', designed to highlight and further explain

important aspects of biblical texts. This was the most general form of illustration; hand-created, individual and unique. This changed in the fifteenth century however, when books began to be illustrated with woodcuts – most notably in Germany, by Albrecht Dürer.

The first creative impulses of a painter or sculptor are commonly expressed in drawings, and architects and photographers are commonly trained to draw, if for no other reason than to train their perceptual skills and develop their creative potential. Initially, artists used and re-used wooden tablets for the production of their drawings, however following the widespread availability of paper in the fourteenth century, the use of drawing in the arts increased. During the Renaissance (a period of massive flourishing of human intellectual endeavours and creativity), drawings exhibiting realistic and representational qualities emerged. Notable draftsmen included Leonardo da Vinci, Michelangelo and Raphael. They were inspired by the concurrent developments in geometry and philosophy, exhibiting a true synthesis of these branches – a combination somewhat lost in the modern day.

Figure drawing became a recognised subsection of artistic drawing in this period, despite its long history stretching back to prehistoric descriptions. An anecdote by the Roman author and philosopher Pliny, describes how Zeuxis (a painter who flourished during the 5th century BCE) reviewed the young women of Agrigentum naked before selecting five whose features he would combine in order to paint an ideal image. The use of nude models in the medieval artist's workshop is further implied in the writings

of Cennino Cennini (an Italian painter), and a manuscript of Villard de Honnecourt confirms that sketching from life was an established practice by the thirteenth century. The Carracci, who opened their *Accademia degli Incamminati* (one of the first art academies in Italy) in Bologna in the 1580s, set the pattern for later art schools by making life drawing the central discipline. The course of training began with the copying of engravings, then proceeded to drawing from plaster casts, after which the students were trained in drawing from the live model.

The main processes for reproduction of drawings and illustrations in the sixteenth and seventeenth centuries were engraving and etching, and by the end of the eighteenth century, lithography (a method of printing originally based on the immiscibility of oil and water) allowed even better illustrations to be reproduced. In the later seventeenth and eighteenth centuries, the previous combination of the arts and sciences in drawing gave way to a more romantic and even classical style, epitomised by draftsmen such as Poussin, Rembrandt, Rubens, Tiepolo and Antoine Watteau. Mastery in drawing was considered a prerequisite to painting, and students in Jacques-Louis David's Studio (a famed eighteenth century French painter of the neo-classical style), were required to draw for six hours a day, from a model who remained in the same pose for an entire week!

During this period, an increasingly large gap started to emerge between 'fine artists' on the one hand, and 'draftsmen' / 'illustrators' on the other. This difference became further complicated with the 'Golden Age of Illustration'; a period customarily defined as lasting from the

latter quarter of the nineteenth century until just after the First World War. In this period of no more than fifty years the popularity, abundance and most importantly the unprecedented upsurge in quality of illustrated works marked an astounding change in the way that publishers, artists and the general public came to view artistic drawing. Arthur Rackham, Walter Crane, John Tenniel and William Blake are some of its most famous names. Until the latter part of the nineteenth century, the work of illustrators was largely proffered anonymously, and in England it was only after Thomas Bewick's pioneering technical advances in wood engraving that it became common to acknowledge the artistic and technical expertise of illustrators. Such draftsmen also frequently used their drawings in preparation for paintings, further obfuscating the distinction between drawing/painting, high/low art.

The artists involved in the Arts and Crafts Movement (with a strong emphasis on stylised drawing, and a powerful influence on the 'Golden Age of Illustration') also attempted to counter the ever intruding Industrial Revolution, by bringing the values of beautiful and inventive craftsmanship back into the sphere of everyday life. This helped to counter the main challenge which emerged around this time – photography. The invention of the first widely available form of photography (with flexible photographic film role marketed in 1885) led to a shift in the use of drawing in the arts. This new technology took over from drawing as a superior method of accurately representing the visual world, and many artists abandoned their painstaking drawing practices. As a result of these developments however, modernism in the arts emerged – encouraging 'imaginative

originality' in drawing and abstract formulations. Drawing was once again at the forefront of the arts.

There are many different categories of drawing, including figure drawing, cartooning, doodling and shading. There are also many drawing methods, such as line drawing, stippling, shading, hatching, crosshatching, creating textures and tracing – and the artist must be aware of complex problems such as form, proportion and perspective (portrayed in either linear methods, or depth through tone and texture). Today, there are also many computer-aided drawing tools, which are utilised in design, architecture, engineering, as well as the fine arts. It is often exploratory, with considerable emphasis on observation, problem-solving and composition, and as such, remains an unceasingly useful tool in the artists repertoire.

The processes of drawing is a fascinating artistic practice, enabling a beautiful array of effects and creative expression. As is evident from this short introduction, it also has an incredibly old history, moving from decorations on cave walls to the most advanced, realistic and imaginative drawings possible in the present day. It is hoped that the current reader enjoys this book on the subject.

CONTENTS.

		PAGE
CHAPTER I.	PASTEL AND ITS ORIGIN—COMPLEMENTARY COLOURS	5
,, II.	MASTERS WHO HAVE RENDERED PASTEL FAMOUS	8
,, III.	MATERIALS — SOFT AND HARD CRAYONS—DIFFERENT SURFACES	10
,, IV.	SKETCHING-IN	13
,, V.	HATCHED LINES AND HEIGHTENING	16
,, VI.	PASTEL BY RUBBING	18
,, VII.	BACKGROUNDS	20
,, VIII.	DRAPERIES	22
,, IX.	THE HEAD—THE HAIR	25
,, X.	FLOWERS AND FRUIT	28
,, XI.	LANDSCAPE AND MARINE SUBJECTS	30
,, XII.	FEELING AND OBSERVATION	32
,, XIII.	FRAILTY OF PASTEL—SHOULD IT BE FIXED?	34
,, XIV.	CONCLUSION	38

CHAPTER I.

PASTEL AND ITS ORIGIN.—COMPLEMENTARY COLOURS.

PASTEL, from the Latin *pastella*, a little stick, is a kind of painting executed with soft crayons of various colours. These crayons are made of a paste containing one or more colours mixed with more or less white; for, in this painting, by mixing white with the other tones beforehand, an infinite variety of tints is produced, each colour diminishing by almost imperceptible gradations, from the most intense shade to pure white; and several colours are ground together to form a scale of greys, or broken tints. In fact, it is painting with coloured crayons, and there is no better preparation for it than the making of charcoal, red chalk, or crayon studies. One may even begin by studies in charcoal, worked over with pastel.

This kind of painting is both the easiest and the most pleasing. To reproduce the bloom on beautiful fruit, the fresh colouring of complexion, or the charm of landscape, nothing serves better than the powder of these many-coloured crayons.

Although Pastel is an easy style, it must not be supposed that a preliminary study of drawing is not necessary. You must already know how to draw, how to reproduce, in charcoal or crayon, the exact contour and relief of a head, or of some other object, and have learnt to compare the different values of light and shade. Without this knowledge, the work would be faulty from its foundation; grave

faults of drawing would entirely mar the charm of the colouring, and relative values ill-observed would disfigure the objects portrayed. It is, therefore, to an already trained and skilful reader that I address these remarks, and to one whom technical terms will not frighten. If the reader has already had some practice either in water-colours or in oils, he will soon find the handling of pastel-colours easy and agreeable; but if, on the other hand, he has never handled any but black and white crayons, the use of a diversity of colours may greatly embarrass him, and it will be useful, nay indispensable, to furnish him beforehand with some information as to the colours, their harmony, their contrasts, and the laws by which they are governed.

Everyone knows that the colours of the rainbow are—orange, yellow, green, blue, violet and red.

Of these colours, three only are fundamental or primary; blue, yellow and red—these form white light. For instance, spin rapidly a ball painted in equal segments of red, blue and yellow—it will appear white.

The other colours are called binary. They are thus called because it requires two primary colours to compose them. These are—orange, composed of red and yellow; violet, composed of red and blue; and green, composed of blue and yellow. Every binary colour thus obtained has its complement in the primary colour which has not served in its formation. Thus, if green (made of yellow and blue) is placed by the side of red, the green will be seen to attain its maximum of brilliancy and intensity, and so with the red. The experiment may be made by cutting out a round piece of red cardboard and placing it by turns, first on a green background, and then on some other ground—grey, for example. The red will seem brighter and more

brilliant on the green ground, and on the grey ground it will become darker and duller.

The same law exists for the other colours, both primary and binary. Yellow is complementary to violet (composed of blue and red); blue is complementary to orange (composed of red and yellow).

But these complementary colours, heightened and acquiring value when placed side by side, are destroyed if mixed with the binary colour which they should complete. Thus, if you place red and green side by side, you have two splendid tints, enhancing each other by contrast; but if you mix them together, you get a dirty grey, devoid of any brilliancy. It is the same with the other complementary colours—violet and yellow in close proximity have a most harmonious effect, and are charming in opposition, but their amalgamation is grey. Blue and orange, also, so rich in tone when contrasted in a composition, only produce an insignificant grey when mixed.

These laws of colours may be studied with advantage, and their knowledge is indispensable for giving value to the various parts of a composition, and infusing harmony in pictures, especially in pastel-painting, where the tints are somewhat limited and where very often, to obtain the exact shade which cannot be ready made, one tone has to be laid over another and cross-hatched lines employed with colours that complete and perfect each other towards the desired effect. Thus, over a yellowish red, too violent in tone, a few hatched lines of blue will give it quite a mellow and velvety appearance. Or else, if the right tone, a grey for example, fails to give satisfaction, some pale vermilion may first be lightly rubbed over it, then some greyish blue, which will produce a charming violet-grey.

For the shadows and half-tints of any colour, its complementary colour should always be used, in order to obviate any harshness of tone, which happens when a colour is shaded by itself. These contrasts are very noticeable, particularly in draperies, where a thousand tints and coruscations are produced by the reflection of one fold from another and the reflection of all surrounding objects, that often modify the primitive colour. But we shall return to this subject when we come to Draperies.

CHAPTER II.

MASTERS WHO HAVE RENDERED PASTEL FAMOUS.

LET us say a few words about the Masters who have made Pastel famous.

It is probable that the easy and agreeable method of pastel-painting has tempted great painters for several centuries past. In France, works executed in pastel are found of the time of Charles IX. and Henry III. The Louvre Gallery possesses several of this period; one in particular is dated 1615. The really great epoch of Pastel is the eighteenth century—the time of Latour, Perroneau, Greuze, &c. Boucher, Nattier, Louis Tocqué also painted in pastel with great success, and gave an infinite charm to the graceful women of their day.

The Louvre Gallery possesses, by the side of Pastels of that great period—including those of Latour, so delightfully soft and velvety, and those of Chardin, so very

life-like—some works by Prud'hon, admirable for their frank and truthful colour, and bolder in touch than those of the old Masters. It is a sort of transition between Pastel of last century and Pastel of the present day. For, in our time, especially since the last ten years or so, this charming style of painting has not only found admirers, but also great Masters, who have belied this prophecy of Diderot's : 'In spite of all that may be done, Pastel will always be unworthy of a great artist.' Great painters, indeed some of the best, have employed pastel-crayons with the happiest results, and by the breadth of their touches, the vigour of their tones, and the boldness of their hatched lines—often left undisguised as in a sketch —have in some sort created a new style, which perhaps has not the exquisite delicacy of the Pastels of the eighteenth century, but which sometimes produces rich and vigorous tones, giving the appearance of oil-painting.

Landscape painting in Pastel, much neglected last century, is now studied with success, and in the inspired fingers of our best landscape painters, the many-coloured crayons adapt themselves wonderfully, not only to rapid notes taken during a sketching tour, but also to serious and matured works, which are the true expression of a Master's talent and an exact impression of an effect in Nature.

CHAPTER III.

MATERIALS—SOFT AND HARD CRAYONS—DIFFERENT SURFACES.

THE articles indispensable for beginning the study of Pastel are:—

A box of soft pastels.

A box of semi-hard pastels.

A wooden frame stretched with canvas or paper.

You should also have as accessories for facilitating the work:—

A palette-knife to scrape the surface of the canvas and remove an objectionable tone, or one that is too heavy.

A paint-brush for dusting lightly and removing any lumps that may have been formed.

Some bread-crumbs for rubbing out.

The selection of a box is very important. The scale of colours for a head is different to that for landscape.

For a head the key of the colouring must be rather quiet and harmonious, being composed of lakes, light red, vermilion, cobalt, emerald green; Vandyke brown, burnt sienna, raw sienna, yellow ochre, Naples yellow, and their gradations diminishing to white, with broken tints made of mixtures of pure colours, forming a series of bluish greys, violet greys, pinky greys, and greenish greys, most precious for giving velvety final touches.

In the box for landscape, flesh-colour tints are almost useless, except for certain delicate sky-tints, and an extensive variety of browns and greens is requisite (yellow greens, blue greens, russet greens, &c.).

For flower-painting, the box should be composed of every possible tint, and I cannot too strongly advise an artist who wishes to devote himself to this study to have the richest collection of pastels he can get together. One box is not enough, for in Nature the wonderful hues to be represented have an infinite variety.

The most complete boxes are divided into compartments on trays, one above the other, in which the pastels are arranged by series of colours so contrasted as to form a whole pleasing to the eye. It is impossible, however, to preserve this arrangement when you are at work. The time lost in seeking for the required colour, first in one compartment, then in another, would be too great. It is a good plan, before beginning your work, to make a sort of palette for yourself with such scales of tones most necessary to the work you wish to do. Take for the purpose a long flat box, or one of the drawers of the box, divided into three rows. Here, for an example, is a palette-box for figure-painting :—

1st row.—Burnt lake, carmine, red brown.

2nd row.—Green and greenish tints, violet and violet tints, bluish grey.

3rd row.—Black, dark brown, light brown, yellow brown, yellow, pale blue, dark blue.

The suggestion of this palette is certainly merely a piece of advice ; but I think it good and useful. Everyone is at liberty to follow it or not, as he pleases. At any rate it is indispensable to break up the arrangement of the ready prepared boxes, and to sort the colours in groups with due regard to their gradation and harmony, so as to have vigorous tones, light flesh-tints, or half-tones ready at hand, according to your requirement. You must not

worry yourself too much if in the course of your work, or even in the box itself, some of the pastels get broken. Broken pieces are infinitely easier for use than whole sticks, and very often in order to compose a box, or to give a touch you find yourself obliged to break a crayon that is too long.

The soft pastels serve for sketching-in and for carrying the work as far forward as possible. The semi-hard ones serve to give precision to certain details in the drawing, to give firmness to some parts, and emphasis to others. They are used for finishing. You must be careful not to employ them too soon, or they would give dryness to the work. When a soft pastel is too thick to mark a delicate feature, it may very often be cut to a point before using, like a pencil.

The box of semi-hard pastels must be in harmony with the box of soft pastels. The number of tones of the former is much more limited. They should be kept apart and not mixed in the palette-box, lest they should be mistaken for soft pastels.

The surface on which pastel is applied is of the greatest importance, both as regards its preparation and its degree of smoothness or roughness, for it is important that the pastel-powder should adhere in a lasting manner, so that one may be able to work a long time without teasing the work. This applies particularly to portraits.

There are many kinds of paper. Pumicif paper—charming, especially for sketches and things rapidly dashed-in ; anti-ponce, offering greater resources for portraits and permitting more labour ; fluffy paper, rather soft, but giving greater delicacy to the tones ; lastly, canvas primed with plaster, or covered with a greyish

priming—very agreeable as a background, particularly if you wish to leave some accessories unfinished—a thing which, in pastel, often produces a very happy artistic effect.

For sketching, one may use a coarse greyish-blue paper, sold by the yard. Many of the old Pastels were done on this kind of paper, and not a few modern painters use it with great success. By this means you may obtain great qualities of cohesion and delicacy.

Prepared vellum may also be used, its high price alone restricting its use.

These different kinds of paper or canvas require a very different kind of work. It will be well to try the different styles for your studies, and see the advantages they procure according to your own method of work, so that you may be able to master the difficulties they present, and create a process quite your own.

CHAPTER IV.

'EBAUCHE,' OR SKETCHING-IN.

BEFORE using the pastel-crayons you should sketch-in your subject, either head or landscape, with a piece of charcoal, taking care to avoid thick black outlines, or the too frequent application of bread-crumb, which might tear up the surface of the paper and make it greasy. Mass the shadows lightly with charcoal, and even add a few touches of white chalk, if it be a portrait, to make sure of the different values.

The sketch being finished, remove any superabundance of charcoal by dusting it lightly with a paint-brush, or by striking the frame with little knocks, in such a way as to make every particle drop off that is useless for the effect. Then take your pastel-box and choose the tones that are most suitable to the study you wish to execute. If it is the head of a dark man, the key will have to be warmer than for the delicate complexion of a fair girl; in the same way, the tone for a sunset will be sombre and ruddy, whereas it will be luminous and silvery for a morning effect.

I will take the *ébauche* of a head as an example, for it is the most difficult. Landscape painters will find it easy to apply what I shall say concerning the features, to the principal lines of their landscape.

When we look attentively at a face and try to analyse it simply, we see that, with the exception of a few delicate differences of colour, the whole may be summed up into three tones: shadow, half tint, and high light—each being more or less intense according to the amount of relief.

Let us suppose the *ébauche* is made on a medium-tinted, or rather light paper. I begin, then, by massing the values of the shadows round the orbit of the eye, the shadow of the nose, that of the cheek, the shadow cast by the head on the neck, and the great shadows of the hair, trying the while to render the exact tone presented in Nature—very deep in the corner of the socket, ruddier in the cheek, and somewhat greenish in the throat. This at first should be too strong and too warm in tone, for the groundwork ought always to be an exaggeration of Nature. The handling of this preliminary work should be both rich and broad. If the pastels are broken, the pieces even may be used, rubbed

on flat. By this means a greater richness of tone is obtained. In any way, small, dry hatched lines made with the pastel point should be avoided.

When the shadows have been massed-in, proceed in like manner with the high lights, taking yet greater care to obtain the exact richness of tone, for the difference in the colouring is greater here. The tone of the cheeks is ruddier or pinker, while the forehead is paler or whiter, and the nascent bosom of a more delicate colour, slightly tinged with blue.

These high lights should be laid on very boldly, with a broad, daring touch, and as far as possible at the first stroke.

The design having been thus crudely parcelled out into samples of light and dark tints, choose from among your broken tints some greys, tinged with green or pink, and lay-in, side by side, the half tints in their exact shapes. If the paper is rather dark in tone, it need not even be covered entirely over, and the ground may be allowed to show through in places. If, on the contrary, the *ébauche* is done on white or very light-coloured paper, always begin by the shadows, but mass-in the half tints before the high lights, the tone of the paper giving the light values long enough.

The image obtained by this first operation is a more or less rough *ébauche*, but it ought to convey an approximate idea of the face to be represented. All the features having been prepared, and the hair massed-in, before proceeding any further it is well to indicate some of the background around the head, taking care to rub it on flat in a liberal manner, and get exactly the right depth of tone in every part that immediately borders on the face.

The corners of your picture may be left unfinished without injuring the effect. It is particularly important, if you have a light auburn or a blonde head relieving against a dull red background, not to prolong the over-vigorous dead colouring of a head that looks like a patch on white ground, because the depth of the background is essential to render the tones their right colour, and very often a tone that seems too violent when first laid on becomes too pale and seems weak when the background is indicated.

The colours for backgrounds are very often thick, soft pastels—grey, brown, greenish, or green. They must be chosen with care, and very often mixed when used—that is to say, if the first coat is too dark or too light, it must be modified by rubbing a tone over it, opposite to it in power, broadly and lightly, which may soften or render it more vigorous.

CHAPTER V.

HATCHED LINES AND HEIGHTENING.

THE rough *ébauche* having reached this stage of preparation, we change our mode of work. The same method of using the pastel-crayons flat might certainly be continued, but then one would have to break them up into very small pieces, so as always to have a bit ready the exact size of the touch required. Moreover, this sort of work demands considerable practice, and is therefore very unsuitable to

beginners. Let us then return to our *ébauche*, working it over with hatched or crossed lines, that permit the indifferent use of pastel-crayons of any length.

For this operation, what we said in Chapter I. concerning primary and complementary colours here becomes useful, for should a tone in the *ébauche* be too dull and too heavy, in order to revive it, I pass lightly over with hatched lines of pure red or yellow, or if it be too hot, too intense, a few strokes of blue or greyish green will mellow and soften it.

So in the passage from shadow to half-tone, and from half-tone to high light, there must be of a necessity a certain amount of dryness in the *ébauche*, even if care has been taken to make the tints cross lightly one over the other where they join. In that case hatched lines made of a tint participating in the two tones that have to be blended together, produce a charmingly soft and well-modelled effect. For, in Nature, except in the case of hard, dry heads of thin persons, where the shadows are clearly cut, the gradation of light is generally produced in a manner that cannot be appreciated by an untrained eye, and the secret of the model's structure once discovered and frankly proclaimed in a bold sketch, the whole science of the painter should consist in removing this harshness, so as to infuse vivacity and life-like grace into his work.

This process of hatched lines must be employed for finishing a Pastel. For the little niceties of features and the delicacy of a likeness, the pastel-crayon may be cut to a point if the tool seems too thick and clumsy. You may also pass your finger lightly over two adjoining tints which need a little cohesion, or blending; but in this case avoid passing a second time over tints thus obtained. This

process, if carried too far, would become dangerous to the work, and the Pastel would no longer retain its fresh colouring.

The hatched lines of which I have just spoken may be left visible if they serve to strengthen the modelling and give precision to the form. But they must not shock the eye, and require to be done with art, otherwise they would deform instead of perfecting.

Some artists indulge in large hatched lines, which they leave very apparent. But this style, although most artistic, preserves a sketchy look, and is ill-adapted to portraits, where a more minute handling is required to obtain a correct likeness.

CHAPTER VI.

PASTEL BY RUBBING.

PASTEL executed with large strokes and light hatched lines constitutes what is called 'the modern style,' or 'the new manner.'

The execution of ancient Pastels it is almost impossible to master, and they only present a lovely amalgamation of velvety powders laid one over the other in an inscrutable manner.

To obtain this result one may proceed in two ways:—

1. On smooth-grained paper or vellum, use a stump to spread the pastel-crayon previously ground into a powder, and proceed nearly in the same way as for stump drawings.

The different tones—shadow, half-tone and high light, should be massed in broadly at first, and accurately in the right place, with clean stumps; that is to say, you should avoid using the same stump for touching in the high lights that has already served to spread the shadows. The result would be a dirty or earthy-looking work, disagreeable in appearance and impossible to be corrected.

The larger tints having been spread, take a soft fine stump made of cork or leather, and blend the tints lightly one into the other.

This method is little practised nowadays, but it should be preferred for copies of ancient Pastels, or for very small works.

2. Nearly the same result may be obtained in a more artistic manner by massing the first tints heavily—shadows, half-tones and high lights—with pastel laid on flat and rubbed hard, then use your finger to spread and blend them together. This execution is often necessary, and is much used as a preparation when the grain of the paper is rough and difficult to cover. The finger has a firmness and an intelligent suppleness which the best of stumps cannot supply.

Very often Pastels most artistically finished with hatched lines have been prepared in this way. Then look out for your poor fingers! They will get quite sore. If large surfaces, a background or drapery, for instance, have to be rubbed in, you may wrap a piece of rag round your thumb and rub hard until the little white or grey specks on the paper disappear; but, I repeat it, with the modern fashion of working Pastel, this kind of execution is particularly suitable to the preparation of the ground-work, and as it makes any thickness disappear which may have

been formed, it leaves a correct *ébauche* ready prepared for the second work, and, already of great value, which may be finished by rubbing and hatched lines.

If the effect of the ancient Pastels is required, the process of crushing pastel, then spreading and rubbing it with the finger should be repeated until the thickness of paste is sufficient, the depth of tone exact, and the likeness or effect obtained.

The drawing for this work should be rigorously correct, for the slightest fault would become intensified, and Pastel-painting overworked would get heavy and woolly.

CHAPTER VII.

BACKGROUNDS.

A BACKGROUND, often neglected by beginners, is of the highest importance. If well done, it sets off the head and gives it sufficient relief. If badly indicated, it spoils all and instead of serving as a foil, it attracts too much attention, and comes forward. If the background consists of a drapery with a pattern or in folds it is a still greater pitfall. Details should be but slightly indicated, allowance being made for distance which makes them appear fainter, or else if they have been marked too heavily at first they should be softened to make them retreat into their proper place. The safest way, when you are working from life, is to place the most suitable background, light or dark, as the case may be, behind your model. For this purpose

drapery of dull or silky material spread over a screen is of great service. You may also use a very large frame or strainer stretched with varieties of paper in lovely tones of tender grey.

The background should always be placed as far away as possible from the model, so that zones of air, however transparent they may be, interposing between the background and the object, give a mellow and vapoury appearance, and constitute the atmosphere of the picture.

The selection of the colour and the right depth of tone for the background are also a serious matter. Nature, well studied, is the best guide in this. Nevertheless there are certain laws of contrast which it is well to know and to observe. Thus when the model has a delicate complexion, and very fair hair, an intense, or at least a rather dark background, will set it off to greater advantage. On the other hand, when the hair is black, that vigorous tone should be left as a dominant note, and if a light background is not chosen, at any rate it should be even.

Plush and velvet form extremely rich and very modern backgrounds. The pastel greys, infinite in variety and soft in tone, also make beautiful grounds, the values of which may clash in opposition very successfully. For instance, a very deep grey ground, almost black, or reddish, well adapted to relieve fair hair, may diminish by successive gradations of grey tints until it melts away into light grey, and blends with the pearly tints of the shoulders, or the silky folds of the drapery. Sometimes the background is not entirely filled in, particularly if the paper has a pretty tone: this produces a very artistic effect and is quite in the modern style. For this, either make the tones melt into the tone of the paper, or indicate some

broad hatched lines, terminating abruptly, and thus producing a successful effect.

Above all, beware of hard marks, or an outline round the head.

Pastel for backgrounds should be rubbed flat over a great space at a time, from top to bottom, or from right to left. Very soft big conical crayons should be preferred for covering the ground, when you can find them exactly the tint you want.

CHAPTER VIII.

DRAPERIES.

ACCESSORIES accompanying a subject—that is to say, draperies and costume for a portrait, furniture and utensils in a composition—should be selected with taste, and executed with great accuracy, but without heaviness. Indeed you often have to subdue and simplify effects in Nature, in order to concentrate all the interest on the figures or figures which form the principal subject of the picture.

The handling of these accessories should be very broad, and freer than for the head. If the face is rubbed-in, the draperies will gain by being executed with broad, bold strokes, made with the crayon used flat, and heightened with hatched lines. As to accessories in a composition, taste is required for grouping the objects, and great accu-

racy in copying them. The study of Nature and the strict observance of planes is most useful advice.

With regard to draperies, the matter is more complicated and gives greater scope to the artist's taste. Very rarely are arrangements to be found ready made, either in tone or in form. Fashion, so frequently exaggerated in its display, should be avoided in its excess, which would prevent a work of art from lasting without ridicule. Therefore, in choosing a lady's dress, or in the choice of draperies, the greatest care should be taken, both as regards colour and form, and everything must depend on the model's complexion and appearance, so as to set off her style of beauty and the accentuation of her individuality to the best advantage possible. Then, the arrangement having been well thought out, with its values of background and draperies, and the eye being quite satisfied, copy it servilely, with as much vigour and freedom as possible.

The sketching-in of stuffs, often crude in tone and sparkling in effect, is of the highest importance. For example, for red, black, brown, blue, or green velvets, &c., and in general for all dark shades, lay-in at first with a very pure, intense tone, all the great shadows and cast shadows in their own particular shapes, which is important in rendering crisp drapery that clings to and reveals the form. Prussian blue, carmine, burnt carmine, &c., are excellent for this purpose, and when rubbed-in give a vigorous groundwork. When these large masses have been grouped, indicate the half-tones, and afterwards the high lights, with large strokes. Do not forget to indicate the reflected lights of one fold from another, and those having reference to surrounding objects. A reflected light always participates in the colour of the material itself and of

whatever touches it. Thus, white satin acts like a mirror, and reflects, almost as well as a looking-glass, all the tints, flowers, and ribbons that accompany it.

Certain pinks, for instance, have cold discoloured lights, and their reflected shadows are of a warm, ruddy hue.

Satins have large planes, or rather large reflects, both light and dark. Velvets, on the contrary, require a very subdued and sober light. The effect is simple; a great mass of intense colour, and a narrow velvety reflect on the side facing the light.

Other kinds of materials are rendered in a simpler way. The shadow and the high light, reflected in a lesser degree, are easier to be observed and reproduced.

For these indications of drapery, you should procure the exact shade of colour as nearly as possible—for the shadows, half tints and high lights—from some other source than the colours in your ordinary palette-box, which are usually rather dull. You should even have some pastels made specially, when necessary. Apply for these at a pastel-colourman's, and ask for a whole graduated series of certain colours, and if you cannot get the tones you want, give a small piece of the dress you have to paint, in order to obtain them perfectly exact.

If the absolute tone does not exist, or if you cannot get it made, cross some pure tones by hatching and lightly rubbing, one completing or modifying the other; but take care to keep the *ébauche* of a rather more violent and intense tone than in reality, for on this vigorous groundwork it will be easy to come over again with cold greyish or bluish modifying tones, whereas it would be impossible to obtain much vigour and real richness of colouring on a groundwork prepared with grey, the opaque tones of which would have the worst effect possible.

Pure or entire tones are rare in pastel. They are: Prussian blue, ultramarine, violet cobalt, lakes and burnt lakes, the siennas, as intense as possible. These pure tones, rich in colour, make excellent first grounds. Some artists even make a successful use of rubbings-in of native red chalk and black crayon, before beginning the *ébauche* of their dark draperies.

These vigorous tones are easily modified by delicate ones, with very thin greys and light rubbings, which of themselves would be dull and cold, were it not for the vigour lying beneath. Lovely tints for half tones may be obtained by placing the tones for the shadows and the high lights side by side and rubbing them lightly together.

A general law in pastel, as in all painting, is to cross the tones and modify them with their complementary colour, in order to obtain more startling effects of a richer harmony. Refer to what I said further back, in the first chapter, on primary and binary colours.

CHAPTER IX.

THE HEAD—THE HAIR.

OF all studies the study of the head is the most interesting though no doubt the most difficult. But, on the other hand, there is nothing more engrossing, nothing more attractive. The creation on a plain sheet of paper, so cold and so commonplace, of a beaming head, full of life, is a serious work, requiring long and patient study. This

branch cannot be attempted by inexperienced amateurs. I speak, therefore, to those who have already had practice in studying the human form, and in copying likenesses in chalk by means of broad masses of shadow and light.

What I have said with regard to ground-work in general applies particularly to a head. The utmost nicety is necessary: you should treat your drawing with respect, and avoid heaviness and pastiness. Be careful in seeking the exact tone, and lay it on boldly, then make the half tints melt delicately by means of bluish greys or violet greys, lightly rubbed in.

For the delicacy of the features which gives the likeness, it is often necessary to employ semi-hard pastels, that serve as a stump and give minuteness to the work, or else, if these pastels seem too hard, you may cut the soft crayons to a point and use them as pencils to give the finishing touches to the eyes, the nose, and the mouth. It would be impossible to draw the pupil of the eye or a finely-cut lip with crayons a quarter of an inch thick.

This process will of a certainty produce a velvety appearance and high finish, which will render well the bloom of the flesh.

For the hair, on the contrary, the handling should be —I shall not say careless—but broad throughout. Work as much as possible with the pastel used *flat*, to indicate the large waves and masses. Observe well in fine silky hair the violet-tinted quality of the high lights and the delicate reflected lights in fair curls.

Fair hair is prepared with the ochres, raw and burnt sienna, and greenish-brown tones for the shades; the high lights are of a very soft grey tinged with violet.

Brown hair should be prepared with a very warm and

very intense ground-work, with burnt lakes and lakes mixed with black. Avoid using black by itself, even for very dark hair, for black is naturally cold, and there is a richness of tone and vitality in hair which black cannot render. The effect obtained would be rather that of a stiff material than that of a silky mass.

The high lights are also tinged with blue or violet, and the reflected lights with a little burnt sienna.

Great care should be taken to avoid any hardness where the flesh meets the hair. If the hair is raised up in the Louis XV. style, mark well the shape of the forehead with its modelling, and the roots of the hair by blending the tone of the forehead and the hair lightly together, so as to make the transparency of the last rows of hair apparent, thus producing in dark heads a light blend almost bluish in tint. If, on the contrary, the hair is in loose curls, indicate the mass and the shape of each curl, then its cast shadow on the forehead, and be sure to preserve the value of the half-tint which envelops the whole of the upper part of the head, if the mass of small curls is sufficiently thick.

You should always be careful to make the hair appear light and supple, and for this avoid any thickness of pastel, blend and scrape if necessary, and work as much as possible with the pastel used *flat*, the better to indicate the large masses and wide waves.

CHAPTER X.

FLOWERS AND FRUIT.

FLOWERS and fruit are one of the most charming studies for pastel; but this study, in which the most various and the brightest colours are brought side by side and mingled together, requires an extreme richness of tint in the palette-box, for it would be impossible, in spite of all the talent in the world, to paint a bouquet of bright flowers with the sober scale of colours of a palette for the face. Deep lake, rose lake, and orange lake, and their graduated shades are necessary, as also a complete series of beautiful greens of all shades, some deep tones and warm browns.

Before painting flowers, they should be tastefully arranged in groups according to their colours, that is to say, taking care to place the tones that complete and set each other off, side by side, and united together as much as possible in masses, in such a manner as to form light or dark values.

White flowers, snowballs, or large daisies, for instance, present a soft harmonious mass, contrasting well with the rich tones of coloured flowers, whereas if these slender daisies are scattered like white stars amidst other flowers of violent hues, they will produce a spotty, disagreeable effect, and one that is very inartistic.

Fruit should be arranged in groups, or piled up. Some of the fruit may be cut open to break the monotony of spheric shapes. Above all, avoid placing all the fruit turned towards you and on the same plane, which would

be a fault in composition. The best guide for this is
natural taste, developed through the counsels of a good
master, or perfected by reading a special treatise on composition.
Light also plays an important part, and may
vary the effects *ad infinitum*. Dispersed, or diffused, light
mars the effect. A single focus of light makes the relief
simpler; a concentrated light makes it more striking.

But let us come to the execution for this branch. For
the groundwork you should proceed as I directed further
back (in Chapter IV.) by exaggerating values of light and
shade as much as possible.

It is very advantageous to work broadly and block in
the mass, much more so than for the face, where necessarily
the delicacy of the features and the desire to preserve
the likeness hamper the handling. Above all, aim at
obtaining the luscious pulp of fruit, and the grace and
delicately-coloured petals of a flower.

When the first outline is exact and the masses correct,
the precision of details will easily follow. Try especially
to obtain a rich and solid key of colour and correct drawing.
With this object in view, you should carefully respect
the intensity of the strong values, the shadows, the cast-shadows,
and the relation of one value to another. Lastly,
lay-in your groundwork quickly, and, if possible, all at
once. It would be impossible to finish a rose of a delicate
tint on light paper without having previously indicated the
dark mass of foliage that surrounds it, or the intensity of
the bright colours that happen to be near it.

Still life is also an excellent study, less agreeable
perhaps, but useful as a preparation for more seductive
studies that require a more spirited kind of work. You
may study at leisure effects of light and shade and contrasts

of colour on some objects arranged in a group which will remain always the same for weeks and months; whereas flowers alter their appearance from hour to hour, and fruit itself decays, after too lengthy an exposure to the light, or at least loses its freshness and brilliancy.

CHAPTER XI.

LANDSCAPE AND MARINE SUBJECTS.

PASTEL has been very little used for landscape by the old Masters, but in our own days great artists do not disdain making use of it, and successfully obtain lovely effects, very supple in tone, and extremely exact in colour.

Everyone has his own particular style. Some render the effects of bright sunshine marvellously well, and are enthusiasts for daylight. Others prefer the late mysterious hours of twilight, or the silvery mists of morning. In these subjects, more than in any other, you may show your individual bent, and may follow your own particular inspiration.

It is necessary, above all, to observe and simplify. Some general advice will be sufficient here. I shall be teaching nothing new if I say the sky, generally blue in colour, melts towards the horizon into infinitely delicate tints of violet, rose, and yellow.

For cloudy skies, the use of greys of every shade is indispensable. Beware of tones that are too cold and too white, even when rendering luminous skies. Those tones,

weakened by contrast with the foreground, would produce 'a papery effect,' as they say in the language of the studios, to designate a bad production without any relief or depth.

In representing ground, the observation of planes is of the highest importance. Some notions of general perspective are absolutely necessary.

Be careful to simplify distances, and render them with rather intense violet tones, and even with ultramarine blue, in the case of very distant hills or mountains.

The foreground, on the contrary, should be made out with the greatest precision, and rendered with very intense and very warm tones. If the pastels appear rather cold for the effect you want, you may warm them up, or darken them, by lightly rubbing over the groundwork with red chalk, No. 3, some shade of light red, or burnt sienna. The glaring crudity of certain greens, and the heaviness of some shades of violet, are thereby mitigated.

The thing to be dreaded most in a landscape is dryness of outline. An atmosphere, more or less dense, always exists between the spectator's eye and the landscape he is looking at, and prevents the existence of any harshness, particularly in cold foggy climates, or at the twilight hour.

It is this that gives the pictures of the Dutch Masters all their charm, and makes the poetical key-note of Corot's talent. Pastel adapts itself wonderfully well to qualities of harmony and mellowness. Scumbling a bluish grey tint over the outline, or blending the trees and distance together softly with your finger, is often sufficient for this.

Effects in marine painting are simpler. You must first establish harmony between the sky and the sea, and take care to define the horizon, so as to give great depth to your picture.

Reflected lights should be the object of serious study. Water acts as a looking-glass, and reflects the image of whatever happens to be above the surface almost exactly upside down; but you must not forget that this mirror is a moving one, that the least breath of wind disturbs it, at sea especially, and then the waves both large and small, reflect also the colour of the sky, cutting the reflected image across with blue, silvery, or roseate streaks, accordingly, as the sky is clear, the sun shining or setting.

The same observation applies equally to water in a landscape. Nevertheless, if the water is shallow, it reflects badly. The bed can be seen as in little streams and torrents, of which the water is extremely limpid. The water then is reddish or green, according to the colour of the stones or weeds that form the bottom.

But all these observations are of little use to the real artist who studies Nature seriously, and strives to represent what he sees. Personal observation is everything, and alone creates true art.

These few hints are intended rather as a note to attract the reader's attention to the objects that come beneath his eye, and to enable him to reap a fruitful harvest from his studies.

CHAPTER XII.

FEELING AND OBSERVATION.

THE general rules of perspective, the different methods of working in pastel, either by rubbing or hatched lines, a good assortment of colours in the palette-box, all that may

be acquired by the help of advice, or by seeing a good master at work. But that which is not explained or acquired so easily, is the impression produced on an artist's eye by the object he wishes to reproduce, either a head, flowers, or landscape.

Some are born artists, that is to say, they are capable of being impressed by Nature in a personal, interesting, original manner. Some are born colourists—that is to say, they feel better than others do the innumerable harmonies of the colours in relation to each other, their contrasts, their affinities, and their laws. Colourist, for instance, does not mean one who uses warm bright colours; but it is one who knows how to appreciate their subtleties, and above all employs them correctly. For an object that has been well examined, well observed, well studied, is easily executed: it is the education of the eye that has to be gone through and perfected day by day. The study of the best Masters is excellent for learning, to produce certain effects, and for the great laws of composition; but Nature is the only school where the real artist can study at any time, as in an open book, effects that are ever new. The soft and mysterious hours of morning and evening, with their bluish- or violet-tinted mists, tempt dreamy and poetic natures, whilst sunshiny and noonday effects are more suitable to energetic and impulsive dispositions. In the same way, a portrait-painter can create works as marvellous with soft grey tones as those which another of a more ardent temperament will make with bright warm colours.

Everyone must find out for himself according to his own temperament, and create for himself an individual style, the union and combination of what he has gathered

from the lessons of others, observed in the handling of Masters, and learnt from his own experience.

The study of effects of light and shade, of night and morning effects, the relation of colours one to another, their contrasts, their harmonies, their reflected lights, their cast-shadows, &c.—these, are constant subjects for the study of the painter's eye which should never remain inactive.

It is a good thing to make written notes of the result of your observations, the better to remember them. A still better thing is never to begin painting without feeling inspired beforehand on the subject of your work. In this way you may save yourself long hours of that spiritless uncertain work, in which the hand takes a more active part than the mind, and avoid groping about, which is bad, especially in Pastel, where fresh seductive colouring should be obtained from the very first.

You should gaze at your work a long time with half-closed eyes, in order to see everything better on its proper plane; learn your model off by heart, so to speak, and then paint boldly, as fast and as freely as possible, avoiding corrections and false marks.

CHAPTER XIII.

FRAILTY OF PASTEL—SHOULD IT BE FIXED?

PASTEL is delicate work, more subjected than painting in oils to the influences of temperature, and more liable to deterioration after a certain number of years: but a little

care and a few precautions are sufficient to preserve it a long time in a perfect state.

The paper should always be stretched beforehand on a frame covered with linen or strong canvas, to prevent this paper, which of its nature is not very strong, from being damaged or torn by a blow, or by splinters of broken glass.

As soon as the work is completely finished, the Pastel should be covered with a glass, isolated all round by little bands or strips of pasteboard or wood, so as to prevent the pastel powder from adhering to the glass, which would produce some ugly spots and inequalities of modelling, and would cause little by little the deterioration of the picture.

Care must be taken to paste strips of paper to maintain the glass so hermetically over the Pastel, as to prevent any dust or damp from penetrating within; then paste a piece of mill-board behind the frame, to prevent the contact of exterior objects with the stretched cloth backing the Pastel.

If I insist on these details, which concern the framemaker more than the artist, it is because they are of extreme importance for the preservation of Pastel, and are often much neglected, thus causing the terror of those persons who possess Pastels, and giving pastel-painting itself a bad reputation for frailty, which it does not deserve.

I have known persons much distressed because they find a portrait covered with greyish spots and believe it to be spoilt, whereas it is simply nothing more than the impress of a hand that has been placed behind the frame and caused the surface of the canvas or paper to stick to

the glass. It is sufficient in that case, if there has been no rubbing, to take the picture out of the frame and clean the glass. Everything will then be set right and in a perfect state.

For several years past a great deal of attention has been devoted to finding a good fixative for pastel, so as to obviate this frailty and the need of being preserved under glass, which makes it unsuitable to rapid sketches made in the course of a journey or an excursion.

These fixatives, often very good, may be employed with great advantage for studies that will serve as documents for a picture. They are also valuable for fixing the back of a portrait or of an important work ; but I do not recommend them for fixing a beautiful, highly-finished Pastel with a view to doing without a glass. Solidity is thus obtained, no doubt, but at the expense of freshness and colour.

The delicate powder, that renders the bloom of a fine complexion or the lusciousness of a delicious fruit so well, disappears ; the colour but little affected, remains doubtless, but the bloom no longer exists and the Pastel has lost its charm.

Moreover, I have observed after several experiments, that light tints are slightly darkened by the fixative : thus, fair hair or red hair becomes almost auburn. But you can work quite well over a pastel-painting that has been fixed, and you may thus restore 'bloomy' qualities which the first wash of fixative has removed. By this means a work may be produced both permanent and pleasing. A few experiments on old sketches enable the amateur to find out for himself all the advantages that can be derived from fixatives.

But the frailty of pastel must not be over-exaggerated. No doubt it would not withstand rubbing or dusting; but a pastel painting that is well and laboriously executed, and above all properly framed, is very solid. I have seen some perfectly intact, after having travelled about a long time and being exhibited in distant exhibitions.

What perhaps is most to be feared for a Pastel is bright sunshine, for these light powders laid one over the other greatly absorb the light and would easily fade. But this little drawback need not be dreaded too much for the future, as it idealises colours and often makes the portraits of ladies and children more seductive. No one can complain of the soft bluish tones of Latour's Pastels, and there is nothing more charming than the portrait of the Marquise de Pompadour by that Master in the Louvre.

The works of Chardin, much more solid in tone, are extremely vigorous and cannot have changed.

Damp, especially in a country-house, is also a great enemy to pastel. When the paper stretches, bulges up and produces false modelling, then the colours become spotty and mildewed.

Certain materials that are not very permanent should be avoided when you want your work to last a long time. Thus, when a powerful black is required, a kind called *sauce velours* often seems more pleasing for use than the pastel black; the effect produced by it is charming, but it is dangerous, for this black gets into spots and becomes covered with small white fungus, that are very disagreeable. It is far better to obtain the desired effects with real pastel. Prussian blue and the lakes produce a very intense tone, and supply the deficiency in vigour caused by the poorness of the pastel black.

CHAPTER XIV.

CONCLUSION.

THESE few words of advice will, I hope, enable every person who is tempted by the beautiful gradations of a pastel-box, to make fruitful trials for himself. For, of all the styles of painting, Pastel is the one that requires the least amount of preliminary care and allows one to seek for effects of colour, without fearing the unpleasant accidents that are often produced in oil-painting through too much freshness or too much dryness.

I cannot too strongly recommend the study of the complementary colours (see Chapter I.) and also some practice in hatching lines and rubbing with these tones, so that every one may gain personal experience and verify for himself what I have said too briefly. In this lies the great secret, and the only way to find a style of work quite one's own and purely original.

Now I wish success to all attempts, and much pleasure to all those who devote themselves to this engrossing study, interesting beyond all others. I do not think one could abandon it easily after having once commenced, and I feel certain that, with intelligent efforts, it may be quickly pushed to a very high degree of perfection.

THE END.

www.ingramcontent.com/pod-product-compliance
Lightning Source LLC
Chambersburg PA
CBHW020713180526
45163CB00008B/3063